SALT LAKE CITY
GERALD & MARC HOBERMAN

"This is the place"

TEXT BY JASON MATHIS

THE GERALD & MARC HOBERMAN COLLECTION
CAPE TOWN • LONDON • NEW YORK

Photography, concept, design, and production control
Gerald & Marc Hoberman

ISBN 1-919734-43-0

First edition 2001

Published for Eurovast Publications BV by The Gerald & Marc Hoberman Collection (Pty) Ltd
Reg. No. 99/00167/07. PO Box 60044, Victoria Junction, 8005, Cape Town, South Africa
Telephone: 27-21-419 6657/419 2210 Fax: 27-21-418 5987 e-mail: hobercol@mweb.co.za
www.hobermancollection.com

International marketing and picture library
Hoberman Collection (USA), Inc. Representing The Gerald & Marc Hoberman Collection
PO Box 810902, Boca Raton, FL 33481-0902, USA
Telephone: 91-561-542 1141 Fax: 91-864-885 1090 e-mail: hobcolusa@yahoo.com

Agents and distributors

International inquiries
Eurovast Publications BV
Paradijslaan 70, 4822 PG
Breda, The Netherlands
Tel: 31-76-541 8815
Fax: 31-76-542 5932
e-mail: eurovast@yahoo.com

United States of America,
Canada, and Asia:
BHB International, Inc.
108 E. North 1st Street
Suite G, Seneca, SC 29678
Tel: (877) 242 3266
Fax: (864) 885 1090
e-mail: bhbbooks@aol.com

United Kingdom and
Republic of Ireland:
John Wilson Booksales
1 High Street, Princes Risborough
Buckinghamshire, HP27 0AG
Tel: 44-1844-275927
Fax: 44-1844-274402
e-mail: sales@jwbs.co.uk

Printed in South Africa

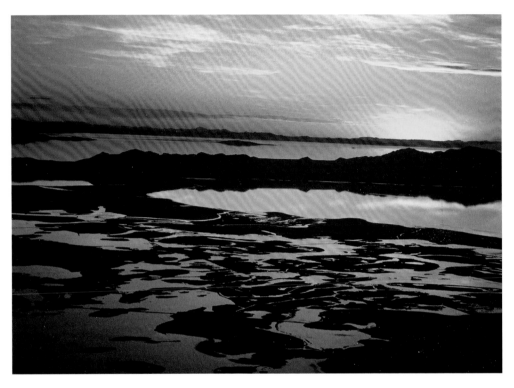

THE GREAT SALT LAKE AT SUNSET

The sun's setting rays reflect onto the saline, quiescent waters of the Great Salt Lake in a vivid, golden-red display. One of the geological wonders of the world, the briny lake is a remnant of a massive inland sea that once covered much of Utah. The mineral and saline content of the lake is eight times greater than the world's oceans, and only the Dead Sea has a higher salt and mineral content than the Great Salt Lake. Larger than any other body of water in western North America, the Great Salt Lake can cover some 2,400 square miles at its highest level. Yet its size belies its shallow depth of an average fifteen to seventeen feet.

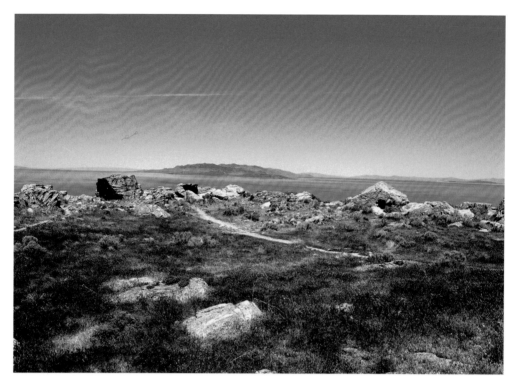

ANTELOPE ISLAND, GREAT SALT LAKE

Native grasses and sagebrush cover a meadow at Buffalo Point on Antelope Island in the Great Salt Lake. The meadow provides a spectacular view of Fremont Island. The rich wetlands that dominate the lake's ecosystem are a sanctuary for more than a hundred species of bird. Antelope Island is also home to one of the largest herds of American bison in the world, which share the space with deer, coyotes, bobcats, and the island's namesake animal, antelope. The island is fifteen miles long and five miles wide and can be reached by sailboat or causeway. The unspoiled beauty of Great Salt Lake is easily viewed from hiking trails and mountain bike routes on the island.

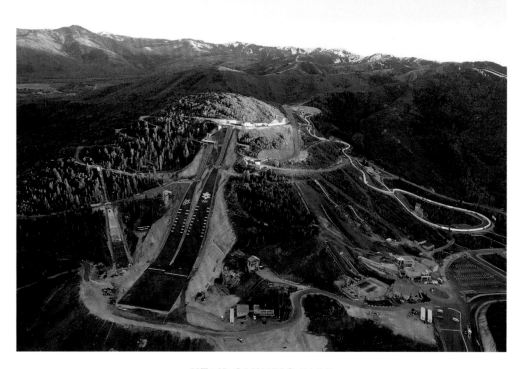

UTAH OLYMPIC PARK

Surrounded by native pines and nestled in a shallow valley 30 minutes east of Salt Lake City, the Utah Olympic Park provides the setting for the bobsleigh, luge, skeleton, ski jumping, and Nordic combined sites for the 2002 Olympic Winter Games. The bobsleigh track, considered one of the fastest in the world, allows athletes to reach speeds of 90 miles per hour. The 120-meter (about 394 feet) ski jump displays the snowflake-inspired logo of the 2002 Olympic Winter Games, while the 90-meter (about 295 feet) jump features a petroglyph-styled ski jumper as a nod to Utah's first known inhabitants, the Ancestral Puebloans.

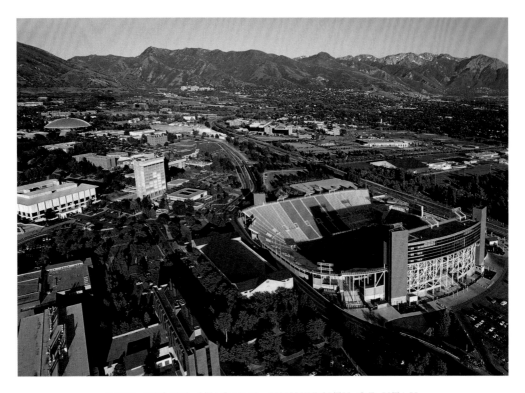

RICE-ECCLES STADIUM, UNIVERSITY OF UTAH

The picturesque campus of the University of Utah surrounds the Rice-Eccles Stadium, site of the opening and closing ceremonies for the 2002 Olympic Winter Games. Remodeled in anticipation of hosting the event, the stadium's twin red stone towers anchor enclosed box seats for dignitaries and journalists, while the seats below can accommodate a capacity crowd of 50,000 spectators. Although the focus of more than three billion people across the world during the 2002 Olympic Games ceremonies, the stadium is at other times the home field of the University of Utah football team.

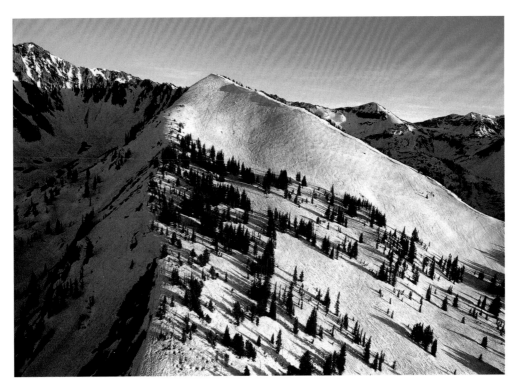

WASATCH MOUNTAINS

The rugged peaks of the Wasatch Mountains beckon snowboarders and skiers with 500 inches of light powder snow every year. Ten world-class ski resorts are less than an hour's drive from downtown Salt Lake City, providing almost instant gratification to locals and visitors alike who trek to the mountains at the first sign of snow. While most skiers are content to enjoy the lower slopes, which are serviced by ski lifts, the high peaks of Big Cottonwood Canyon and Little Cottonwood Canyon tempt the more adventurous, who traverse the ridgelines from the lower ski runs. Seen here in June, ski tracks from the previous winter are still evident in the slowly melting snow.

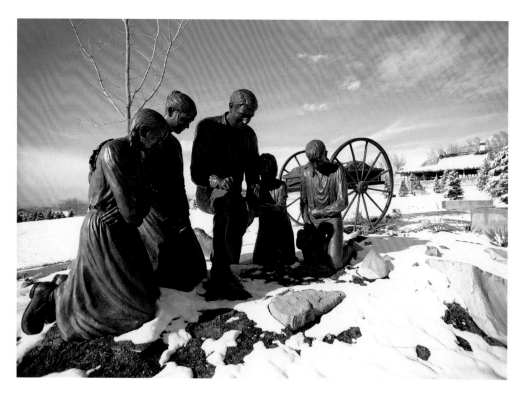

JOURNEY'S END MONUMENT, THIS IS THE PLACE HERITAGE PARK

This expressive sculpture at This Is The Place Heritage Park depicts a pioneer family kneeling, their heads bowed in prayer. The monument is a testament to the dedication and religious devotion of the pioneers who managed to carve out an existence in the harsh western desert. More than 80,000 people crossed the great plains of the United States in handcarts and covered wagons as part of the Mormon migration to the Rocky Mountains of Utah between 1847 and 1869. Leaving behind homes, farms, businesses, and families in Europe and the eastern United States, the Mormon pioneers came west, and found a religious sanctuary in the Great Salt Lake Valley.

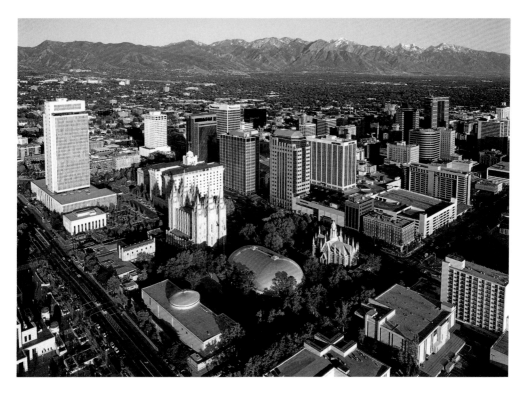

TEMPLE SQUARE

Salt Lake City's Temple Square is the symbolic center of the Church of Jesus Christ of Latter-day Saints. A walled city block in the heart of downtown Salt Lake, the ten-acre Square consists of religious buildings, historic monuments, two visitor centers, gardens, and fountains. The pioneers who laid out Salt Lake City's broad boulevards developed a street numbering system that lists all addresses according to their distance from the Square. The most prominent buildings on Temple Square are the six-spired Salt Lake Temple and the domed Mormon Tabernacle.

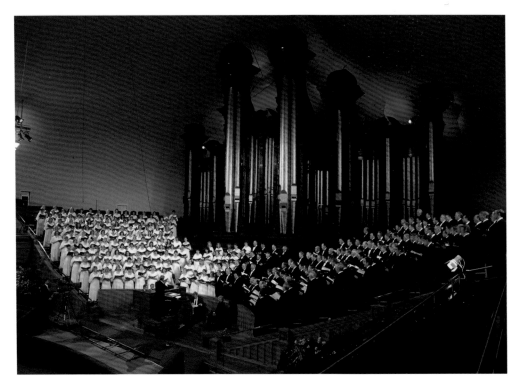

MORMON TABERNACLE CHOIR

The world-famous Mormon Tabernacle Choir has performed in the historic Tabernacle on Temple Square since 1929. The 350 volunteer choir members meet in the Tabernacle on Sunday mornings for a half-hour television and radio broadcast of music and inspirational messages. Crowds of up to 6,000 people gather for the free weekly performance. Built like a huge suspension bridge, the Tabernacle has no internal supports. It boasts amazing acoustical properties, allowing subtle nuances in the music to be heard throughout the vast concert hall. The pipe organ, used to accompany the choir, is equally impressive. With more than 11,000 individual pipes, it is one of the world's largest and most complex musical instruments.

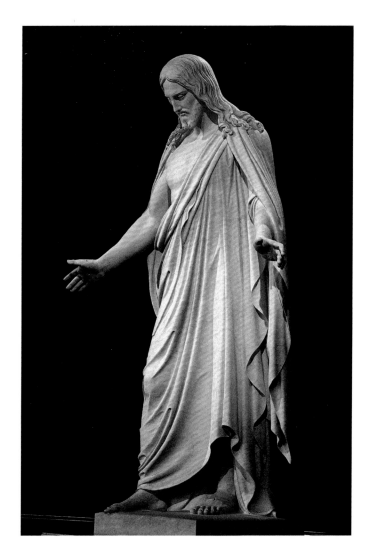

STATUE OF JESUS CHRIST

A marble replica of Bertel Thorvaldsen's *Christus* statue dominates the North Visitor Center at Temple Square. It was reproduced in Florence, Italy by Aldo Rebachi and placed in the Visitor Center in 1966. The original is part of a series of statues that includes the Twelve Apostles. The work was created between 1821 and 1827 for the Church of Our Lady in Copenhagen, Denmark.

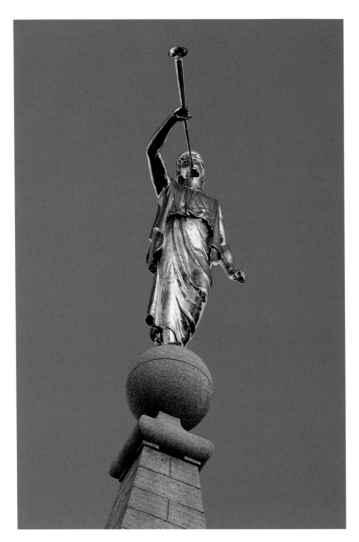

THE ANGEL MORONI

Topping the highest spire of the Mormon Temple on Temple Square, the wingless *Angel Moroni*, trumpet in hand, faces east to herald each new day. Designed by famed Utah-born sculptor Cyrus E. Dallin, the twelve-foot statue is made of copper and is encased in thick 22-carat gold leaf. Members of the Church of Jesus Christ of Latter-day Saints believe that the Angel Moroni appeared to the church's founder, Joseph Smith, and showed him the place—in the hills near Palmyra in upstate New York—where the ancient golden plates that contained the Book of Mormon lay buried. Smith later professed to have translated the Book of Mormon from inscriptions on these plates. Similar statues of the famous angel grace other Mormon temples around the world.

NATIVITY SCENE AT SALT LAKE TEMPLE

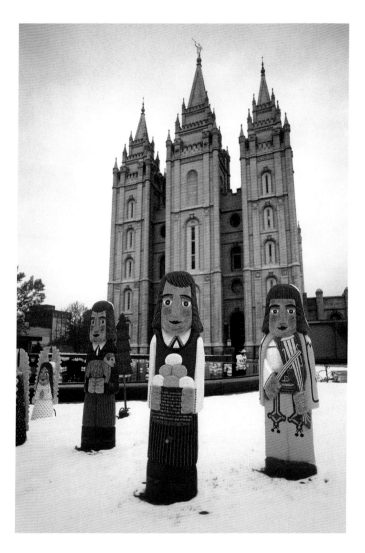

Like silent sentinels, nativity figures seem to stand guard throughout the Christmas season at the castle-like Salt Lake Temple. More than 300,000 tiny lights are used in the Square's elaborate Christmas decorations every year, along with hundreds of garlands, wreaths, figurines, and artworks. In recent years, Temple Square has embraced the theme of multiculturalism, and its displays increasingly depict scenes from different ethnic and cultural groups, reflecting the growing influence of the Church of Jesus Christ of Latter-day Saints outside the United States. In the last few decades the Church has gained millions of new converts in Africa, South America, and the Pacific Islands.

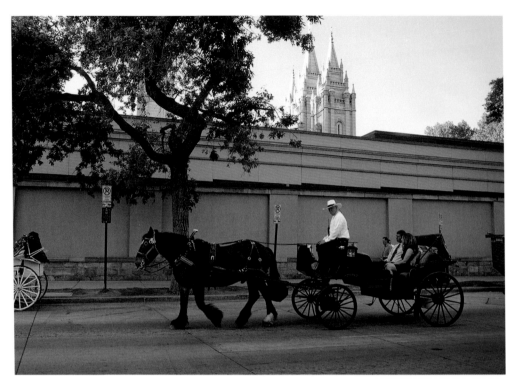

HORSE-DRAWN CARRIAGE AT TEMPLE SQUARE

A horse-drawn carriage outside the walls of Temple Square harks back to pioneer days when cowboys and farmers traveled the streets of western towns in buggies and wagons. Today most carriage riders are tourists, newly-weds, and families who enjoy the novelty of a true horse-powered ride through the modern streets of downtown Salt Lake City.

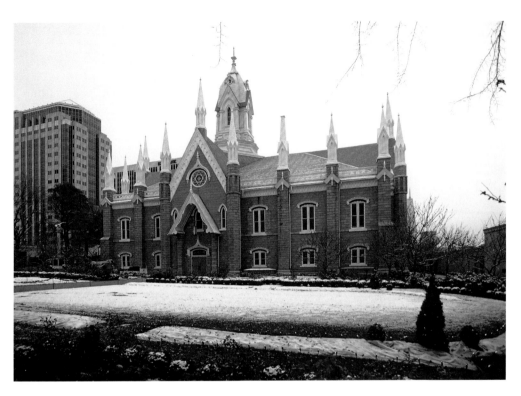

ASSEMBLY HALL, TEMPLE SQUARE

Built with granite left over from the construction of the six-spired Salt Lake Temple, Assembly Hall is one of Temple Square's most charming and intriguing buildings. Designed in the Gothic Victorian style and built between 1877 and 1882, the Assembly Hall has 40 stained-glass windows. To create the richness of oak, the building's designers painted the grains and colors of this wood on the native pine used in the building's interior. The same technique was applied to the woodwork in the more famous Mormon Tabernacle building adjacent to Assembly Hall. The building has meeting facilities for church congregations and hosts free concerts on Fridays and Saturdays.

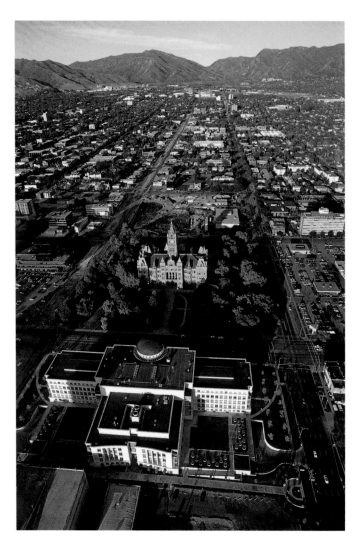

COURTHOUSE AND CITY AND COUNTY BUILDING

Old and new combine in two prominent civic buildings, juxtaposed across State Street in downtown Salt Lake City. Surrounded by lush gardens and mature trees, the turreted City and County Building houses Salt Lake's mayoral and city government offices, and includes chambers for the Salt Lake City Council. Completed in 1894 in the Romanesque style, it was used as Utah's State Capitol for nineteen years before the current statehouse was completed. Depictions of Utah's history are carved above the doorways in bas-relief. Across the street, the newly constructed Scott M. Matheson Courthouse is home to Utah's Supreme Court, the Utah Court of Appeals, and the Third District Courts.

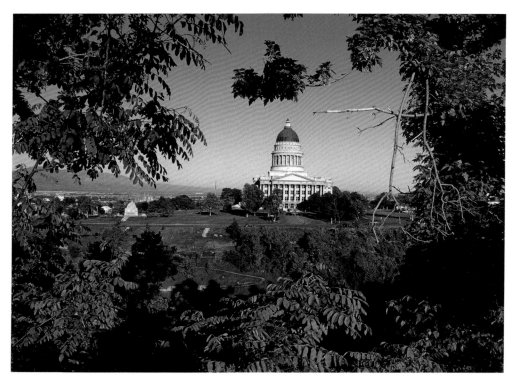

UTAH STATE CAPITOL

Through a window framed by leaves, the Utah State Capitol shimmers in the early morning sunlight. Located on a prominent hill above Salt Lake City, the Capitol dominates the eastern skyline. Designed by Richard Kletting in the Renaissance-revival style and modeled after the US Capitol in Washington, D.C., the building was completed in 1915. The Capitol was constructed of granite from the nearby Little Cottonwood Canyon and its dome created from Utah copper. The state's seat of government is viewed across City Creek Canyon, a popular jogging and biking trail that begins in the heart of downtown Salt Lake and follows a stream for six miles through the mountain foothills of the city.

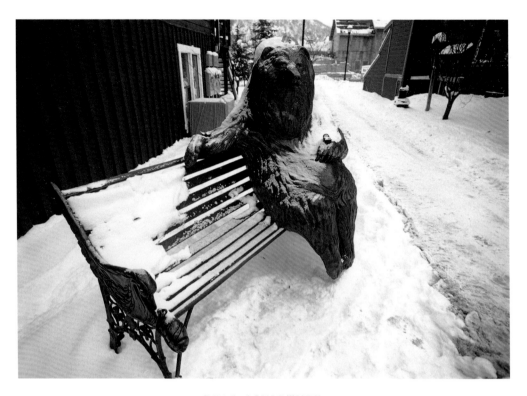

BEAR SCULPTURE

This sculpted bear doesn't seem to mind its chilly seat. Inviting skiers to nestle into its welcoming embrace and unwind on the snow-covered bench, the "friendly" bear is typical of the many carved wooden animals found at ski resorts near Salt Lake City. Life-size sculptures of bears, wolves, coyotes, eagles, foxes, raccoons, and deer decorate the mountain lodges and rustic cabins of these resorts.

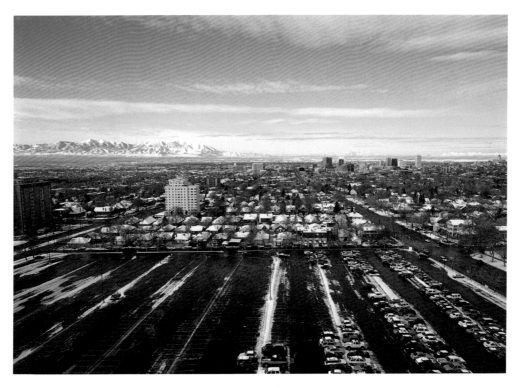

WINTERTIME

Salt Lake City's broad straight streets seem to stretch all the way to the Oquirrh Mountain and the Great Salt Lake along the western horizon. This view from atop the Olympic Stadium at the University of Utah shows tranquil streets lined by snug, cozy homes. Early city planners made sure that Salt Lake's streets would be wide enough to turn around a wagon and a full team of oxen without backing them up. The resulting wide boulevards have made traffic jams virtually non-existent for modern-day motorists.

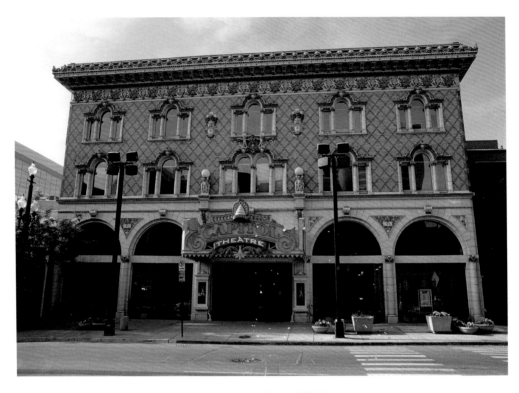

CAPITOL THEATRE

Salt Lake's elegant Renaissance-style Capitol Theatre is one of the city's many performing arts venues. The theater sits in the heart of the city's hotel and shopping district, and attracts a cultured crowd of visitors and locals alike. Home to the Utah Opera Company, Ballet West, and the Ririe-Woodbury Dance Company, the theater also hosts touring Broadway shows, concerts, and musicals. Built in 1913 to host vaudeville shows, the theater was first known as the Orpheum Theatre. Sold in 1927, it reopened in the same year as the Capitol Theatre, with movies being the main attraction. Restored to its original grandeur in 1976, the building is on the National Register of Historic Places.

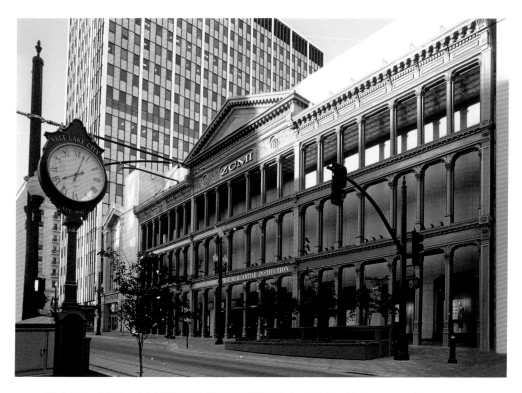

ZION'S COOPERATIVE MERCANTILE INSTITUTION CENTER MALL

Founded by Brigham Young in 1868, the Zion's Cooperative Mercantile Institution claims to be the first department store in the United States. The cast-iron façade dates back to 1879 and its design was inspired by the façades of fashionable department stores in East Coast cities at the time. As Salt Lake City's largest retail outlet for several decades, the venerable institution was a favorite haunt of local shoppers, who bought furniture, clothing, appliances, fine china, silverware, and food items from what was fondly called the "People's Store". When Meier & Frank bought ZCMI in 2000, all the stores were renamed, except the historic downtown ZCMI Center Mall which has retained its original name.

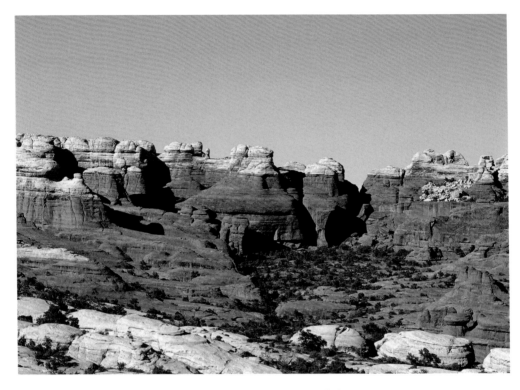

UTAH'S CANYONLANDS

Bright red and white sandstone cliffs contrast dramatically with the blue desert sky, creating a natural patriotic display of red, white, and blue. Few landscapes are as distinctly American as the Canyonlands region of Utah, which conjures up images of the "Wild West" and old John Wayne movies, many of which were filmed against Utah's dramatic red rock background. One of the first movies shot on location in Utah was *Deadwood Dick*, filmed in 1922 and featuring spectacular chases through canyons and across vast plains. More recent films include *Indiana Jones and the Last Crusade*, *Forrest Gump*, *Thelma and Louise*, *Independence Day*, and *Mission Impossible 2*.

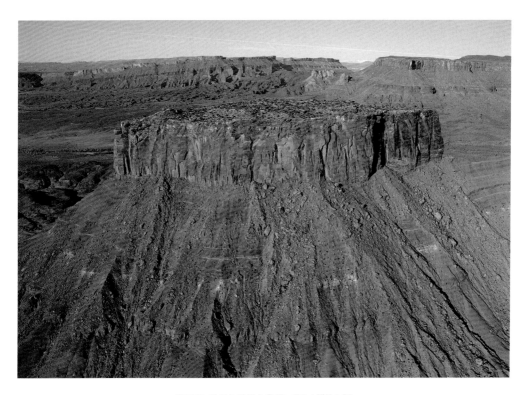

THE COLORADO PLATEAU

A massive red sandstone mesa dominates this desert scene on the Colorado Plateau in southeastern Utah. Hundreds of huge mesas and buttes dot the vast expanse of western land known as the Colorado Plateau, which begins a few hours' drive southeast of Salt Lake City and extends through much of eastern Utah, Colorado, Arizona, and New Mexico. Named for the Colorado River, the plateau encompasses some of the most desolate and beautiful country in the world. Although separated by only a few hundred miles, the red rock formations of this unique region contrast sharply with the alpine scenery and desert valleys of the northern Utah Rocky Mountains that surround Salt Lake City.

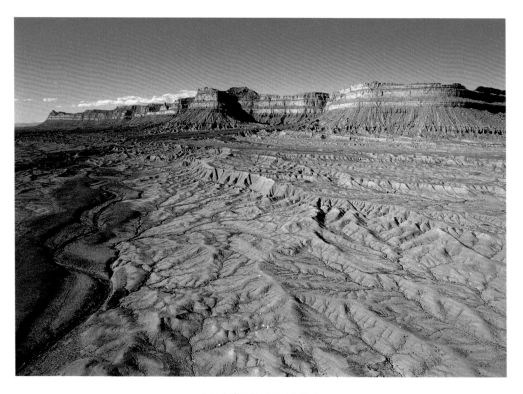

RUGGED BEAUTY

The multicolored sands and mineral-rich rocks of the Utah desert have yielded valuable data from every geological age, enabling geologists to trace the earth's history in the layers of exposed rock found along cliffs and plateaus and in canyons and gorges. To paleontologists the desert is a chronicle of ancient worlds. Here the dry climate and erosion have combined to expose an array of dinosaur fossils, some dating back 145 million years. The discovery of dinosaur remains has helped to make Utah the epicenter of Jurassic research. But it is not only scientists who have been drawn to the desert. Artists, poets, writers, and photographers have found inspiration in the desolate beauty of southeastern Utah.

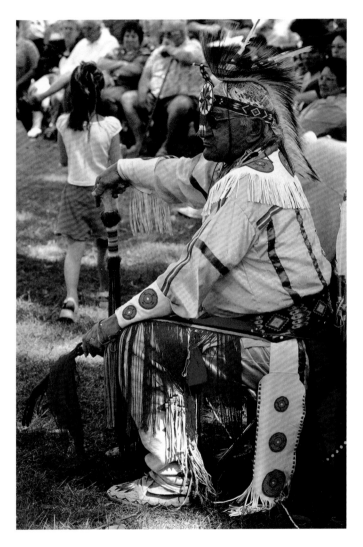

NATIVE AMERICAN
ELDER

A Native American elder, in brightly colored traditional dress, relaxes at a multi-cultural festival in Salt Lake City. The rich heritage of Utah's Native American tribes is preserved through time-honored songs, stories, dances, festivals, dress, tribal education, religious ceremonies, and customs. For thousands of years, nomadic tribes roamed freely across much of the Utah desert, living off the land as hunter-gatherers. Shards of pottery, arrow-heads, and other arche-ological evidence found at various sites in the state indicate that the Fremont and Ancestral Puebloans lived in southern Utah until about A.D. 1300. In early A.D. 1400, Paiute, Goshute, Shoshone, and Ute tribes, followed by the Navajo nation, moved into the area.

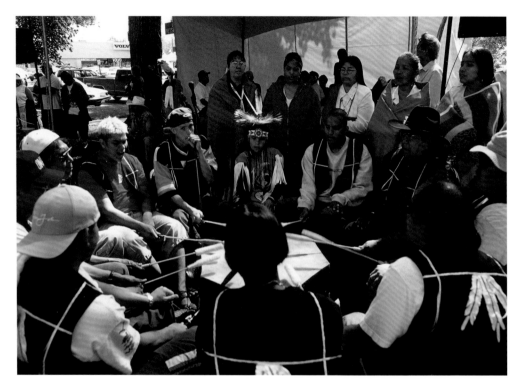

NATIVE AMERICAN DRUM CIRCLE

Young teenagers perform a traditional drum song with older members of a Native American tribe during the Living Traditions Festival, an annual community celebration held in downtown Salt Lake City. The festival honors the rich cultural diversity of Salt Lake's residents. In addition to Native American cultures, the celebration highlights several other ethnic groups who followed the Mormons to the Great Salt Lake Valley. During the three-day festival, the vibrant sounds of Native American drums, Scottish bagpipes, and African American gospel choirs combine with the rhythms of Greek dancers and Pacific Island fire dancers .